Workbench Projects
GREEN-WINGED TEAL PAIR

Glenn A. McMurdo

Wildfowl Carving
MAGAZINE

To my late mother-in-law,
Katharine Joan Penney

Copyright © 2008 by Wildfowl Carving Magazine

Published by
STACKPOLE BOOKS
5067 Ritter Road
Mechanicsburg, PA 17055
www.stackpolebooks.com

All rights reserved, including the right to reproduce this book or portions thereof in any form or by any means, electronic or mechanical, including photocopying, recording, or by any information storage and retrieval system, without permission in writing from the publisher. All inquiries should be addressed to Stackpole Books.

Printed in China

10 9 8 7 6 5 4 3 2 1

FIRST EDITION

Cover design by Caroline Stover

Library of Congress Cataloging-in-Publication Data

McMurdo, Glenn.
 Green-winged teal pair / Glenn McMurdo. – 1st ed.
 p. cm. – (Workbench projects)
 ISBN 978-1-881982-60-9 (hardcover, spiral binding)
 1. Wood-carving–Patterns. 2. Ducks in art. 3. Painting–Technique. I. Title.
 TT199.7.M42 2008
 745.51—dc22
 2008018029

CONTENTS

Foreword	iv
Acknowledgments	v
Introduction	vi
Carving	1
Painting Basics	45
Painting the Green-Winged Teal Hen	52
Hen Paint Swatches	54
Painting the Green-Winged Teal Drake	67
Drake Paint Swatches	68
Taxidermy Photographs	77
Patterns	79
About the Author	85

FOREWORD

I have taken several of Glenn's seminars, and whether he is teaching or writing articles for *Wildfowl Carving*, he always takes his students or readers to another level in both carving and painting. I was unable to attend the courses on the green-winged teal drake and hen that Glenn offered at a local college, so I was delighted to learn that both these birds were being featured as a *Wildfowl Carving* Workbench Project, because I knew everything Glenn taught in his course would be in this book.

Decoy carvers will want to get their hands on this book to learn how to cut out a one-piece blank, make a realistic-looking neck joint, and create an exposed wing on both the drake and the hen. The book also gives detailed paint schedules for both birds.

I thank Glenn for the opportunity to preview this Workbench Project. As a world-class carver, Glenn takes great pride in his teachings, and I know this book will enhance every carver's reference library.

Russ Clark
Bancroft, Ontario, Canada

ACKNOWLEDGMENTS

My thanks go to fellow carvers for their recognition and counsel with regard to my own personal carvings and the different articles and books that I have written and published, especially my first Workbench Project, the decorative wood duck. This gave me the mettle to proceed with this new book. I am also grateful to the hundreds of students that I have instructed over the years for their input and for helping me learn what is most important to teach. A special thank you to Russ Clark for his time and effort, and most of all, to my loving wife, Katharine, for without her, none of this would be possible.

INTRODUCTION

In *Workbench Projects: Green-Winged Teal Pair*, I draw on my years of giving instruction to provide you a book that will both foster the skills of the novice and enhance those of the more experienced carver. Detailed step-by-step photos illustrate all stages of carving and painting. Patterns are included—for both a male and female green-winged teal, and you can choose to carve either one or both.

My objective is to assist you with not only the how-tos, but also the whys. Other carvers may use different, perhaps even better, methods to accomplish the same tasks outlined here. This book describes my techniques, with a logical sequence of carving and painting. If reading this book presents challenges and opens new avenues for you to explore, I have achieved my purpose.

I suggest that you thoroughly read this book from start to finish before you start carving, as each step builds on the preceding and leads up to the next. Keep your tools sharp, and always use safety equipment.

This book features a pair of green-winged teal, both the hen and drake. Green-wings are handsome waterfowl. Although they are North America's smallest marsh ducks, which makes them easy to identify, they are very hardy. Winter usually sets in early here, along the north shore of Lake Ontario, but green-wings often stick around until freeze-up. Their flight is swift and acrobatic, and it's common to see small formations hover just above the vegetation, and then, without hesitation or seemingly any preparation, sit down among a decoy rig. These ducks have a low quack and are gregarious in nature.

The green-winged teal drake was one of the first decorative carvings that I attempted. Since then, I have carved many examples of this species and have been rewarded with numerous ribbons. The drake featured in this book garnered second in species, third in marsh ducks, and third best in show at the 2004 Ward World Carving Championships. The hen won second place in all teals at the 2007 California Open.

Full painting instructions are provided for both birds. Because the patterns for the drake and hen are similar, I am presenting the carving procedures for the hen as a primary focus. Where the techniques differ for the drake, those procedures are demonstrated and explained as needed.

Good luck with your carving projects. I do hope that we have the opportunity to meet somewhere along the line.

Carving

Each carving in this book is sculpted from a single piece of wood, with the glass eyes inserted.

Making one-piece carvings can pose challenges, but it has some advantages: you don't have to work through and try to hide glue joints, and it's easier to achieve a soft, flowing feather layout, especially through the tertial and primary areas. There are also some disadvantages: it can be difficult to locate and carve the head and bill, especially on a low-headed bird, and to undercut in the primary and tertial areas. And if you make a major mistake, it can be hard to remedy. This said, I find it very rewarding to carve a one-piece bird.

Topography

The figures at right shows the names of the regions of the duck mentioned throughout the book. Refer to these figures as needed.

Making Your Own Patterns

Before I tried making my own patterns, I didn't think I could do it: "I've never done that! I can't draw a pattern!" But then I put some thought into the process of patterns and broke it into manageable pieces. Now I believe that if you have the desire to take your work to the next level, you have to make your own patterns.

Start by gathering all the reference materials you can: magazine pictures, your own photographs, commercially available videos, taxidermy mounts, and most important, study bills. If you want to carve both birds, you need hen and drake study bills, because there are differences in size, shape, and length between the drake and the hen of the same species.

When purchasing a study bill, be sure that it has a hydrated appearance. You don't want one that's full of wrinkles and looks withered. This indicates that the bird died long before the casting was made. The bill on the live bird has a leathery, fleshy look, with some wrinkles mainly where the feathers and bill meet. After a bird dies, it starts to dehydrate, causing wrinkles to appear.

TOPOGRAPHY

Numerous publications are available with vast amounts of technical information regarding lengths, widths, and heights of waterfowl. These will give you reference measurements when drawing your patterns. Your local library is a good source for these publications. Another source is the Internet, where you'll find hundreds of websites related to wildfowl.

There is no better reference than viewing live waterfowl, however, and observing the birds' shapes, sizes, and colors. Also look closely to see how each species naturally sits on the water's surface: high, low, front-heavy, or whatever.

To make sure your bird looks realistic, it's important to research the positions waterfowl can get into. Learn the limits of how high or low the head can bend or turn and how the wings and tail move. Keep in mind that ducks do not have bendable backbones like other vertebrates. A duck's back is rigid from where the neck is attached back to the caudal region, the area of the oil gland, where it has a small number of vertebrae that allow the tail area to function. The body cannot bend between the junction of the neck and the caudal region. Also study the feather patterns, shapes, flows, and sizes; usually there is a distinct difference between drakes and hens of the same species.

After gathering all your reference material, look through it for photographs with accurate side and front views. For the side profile, the background should be visible through the nostril hole. For the front view, you should be able to see the same amount of the eyes on both sides of the head. These photos, along with your study bill, give you a good starting point to make an accurate life-size pattern.

Use vernier calipers and dividers to measure study bills.

Start by taking some measurements from your study bill using tools such as vernier calipers and dividers. Measure the culmen from the tip of the bill to the point of the V in the notch at the top of the bill, and measure the height from the corner of the bill to the top point of the notch.

BILL MEASUREMENTS

Measure the widest part of the bill and the width at the hinged area. The last thing to measure, if your study bill provides it, is from the tip of the bill to the center of the eye.

You can now use these measurements to make life-size images of your reference photographs. If the measurement on the profile photo from the tip of the bill to the center of the eye is smaller than this measurement of the study bill, divide the larger measurement by the smaller one. This will give you the percentage to increase the size of the photograph to obtain a life-size image.

For example, if the tip of the bill to the center of eye measures 1.125 inches on the photograph and 2.35 inches on the study bill, 2.35 divided by 1.125 is 2.088, which, rounded up, gives you 209 percent. Thus, to make the original photograph life-size, increase its size by 209 percent.

Conversely, if the measurement from the tip of the bill to the center of eye is smaller than on the photo, divide the smaller measurement by the larger one. This will give you the percentage to reduce the size of the photograph to obtain a life-size image. So if the measurement on the study bill is 2.25 inches and on the photo is 3.3 inches, 2.25 divided by 3.3 is .68, so you would reduce the photo by 68 percent.

If you know the actual life-size dimensions of the live bird taken from the technical publications and also have good reference photographs of the top, side, front, and back views, you can simply reduce or enlarge the size of your photographs as needed to create life-size images.

Make several copies of each life-size image for future use. Then make a life-size composite image of the side view by placing a head profile photograph on a side-view body photograph where it should be located. You can also place additional photos to open up a wing or position the tail up, down, or sideways, connecting these to the composite images with pleasing, flowing lines. Once you're happy with your composite side-view image, trace the outline along with the bird's major topographical areas, and you will have an accurate pattern.

Now transfer the measurements and topography from your new side-view pattern to the life-size top-view photographs to create a top-view pattern.

Making your own patterns is a rewarding and educational exercise that presents new challenges and gives you a wonderful sense of accomplishment. Doing the necessary research increases your knowledge base and helps you understand your subject more thoroughly. It will also help establish your style and give your carvings your own personal signature.

I do not mean to imply that published patterns are not worthy of use. But such patterns, including the ones in this book, are interpretations of a species by others. Making your own patterns allows you to present your version, and I believe that this takes your finished pieces up a notch.

Foreshortening

Foreshortening refers to shortening some lines on an object to give the parts of the drawing the illusion of proper relative size. This helps explain why, when you're transferring information and measurements from the two-dimensional pattern to the three-dimensional carved bird, sometimes the feather or bill layout does not fit properly.

You may need to use foreshortening when transferring two-dimensional patterns to curved or rounded three-dimensional carvings. Dimensions that are not foreshortened on the pattern are the actual outlines of the subject, such as the actual lengths, widths, and heights on both the side and top views. On the top view, the length of the bill is foreshortened, as are the lengths and widths of some feathers where they roll over to the sides. When drawing feathers on your finished carving, ad lib a little to fill empty spaces, again watching for flows, shapes, and sizes.

Wood

For my carvings, I use tupelo wood, which is easy to carve with power tools and sands to a very smooth surface. When choosing your wood, look for a piece that is a light, creamy color, not gray or brown. It should be lightweight and have grain that is straight, not wavy or curly, which would make carving and detailing more difficult. You need a block that measures 10½ x 5¼ x 4 inches for either the hen or the drake.

Setting Up the Band Saw

Adjust your band saw to cut at 90-degree angles both from front to back and side to side. The blade should be square to the surface of the table to ensure square and even cuts. Check the owner's manual for your band saw for methods of setup. Using a ¼-inch skip-tooth blade gives a smooth cut and allows a tight radius while cutting out the wood.

FORESHORTENING

Bill — 1½" — Top View — Scrap of Wood Angled — 1½"

FORESHORTENED VIEW

1 11/16" — Side View — 1 11/16"

ACTUAL LENGTH

Square face of blade to table.

Square edge of blade to table.

1/4-inch skip tooth blade.

Always keep safety in mind when using the band saw. You need to have great respect for this tool. As long as you respect the saw and use common sense, a band saw is very useful. The blade on the saw runs at a high speed but is usually quiet, making it difficult to see that the blade is turning. Never leave a band saw running unattended; that is definitely inviting injury. When cutting out a bird, it's best to be alone, with no distractions. Wear protective equipment, such as a dust mask, eye protection, and ear plugs. Another excellent addition is a dedicated light source on the band saw. It seems the older I get, the more light I need to carve my birds.

Squaring the Block

After you've set up the band saw properly, take time to square your block of wood. Place the flattest surface on the saw table. If the edge next to the fence is irregular, at-

SQUARING THE WOOD BLOCK

4

CARVING

tach a straightedge to this irregularity to guide the wood along the fence. Then cut the opposite side of the block parallel to the fence.

Remove the attached straightedge and place the freshly cut edge against the fence, keeping the original flattest surface against the table. Now cut the second side of the block parallel to the cut side. For the drake and hen green-winged teal, the block of wood should be cut to a 4-inch thickness. This will make the established height to the top of the head correct. Repeat this procedure on the remaining two surfaces, and you should end up with a relatively square block of wood.

1

You will now transfer the pattern to this squared block of wood.

Transferring the Pattern

Cut out the side and top views from the pattern. Using a heavy card stock for your pattern cutouts makes it easier to trace around the pattern with a pencil.

SQUARING TOP AND SIDE VIEW ON WOODEN BLOCK

Establish the top surface of your wood block by looking at the end-grain growth rings to determine where the center of the tree would have been. Use the center of the tree as a guide and make this the bottom of your cutout. Doing this will aid with the balance and flotation of the carving. Draw a reference line 90 degrees to the straight edge at one end of the wood, across the top surface. Then align the square with the reference mark on the top surface, and keeping the square 90 degrees to the bottom edge of the wood, draw another reference line. Divide the top surface in half, and draw a centerline the length of the wood. These reference lines will aid you in transferring the patterns to the wood and ensure that the top and side patterns line up with one another.

Using the reference line drawn at the end on the edge of the wood, line up the side-view pattern with this line and along the bottom edge of the wood, and trace around the pattern.

Now take the top-view pattern, and align the same end of this pattern along the wooden block's top surface reference line at the end of the block. Also use the centerline along the length of the wood for alignment, and then trace around the pattern. From the patterns provided, locate and mark point A on the top view and point B on the side view.

Locate and mark the rectangle outlined around the head, along with the centerline through the center of the head rectangle. Then drill a 1/16-inch diameter hole at point A, down to the depth of point B. You will use this drilled hole later during the roughing-out process.

2

CARVING

Burrs, Cutters, and Stones

You will need several tools for roughing out, cutting, and texturing the decoy. When roughing out, I use a flexible-shaft rotary grinder and aggressive carbide burrs to remove wood quickly. The area that is being roughed out dictates the style and size of burr to use. My most popular shapes are a taper and cylinder in both ¼- and ⅛-inch shank size.

I use a number of cutters in various shapes, sizes, and coarseness of cut. The ones I use most are diamond cutters with a ⅛-inch ball, flame-shaped, and bull-nose, along with safe-end diamonds used for cutting out and layering individual tail, primary, and tertial feathers. Ruby and diamond cutters are fairly interchangeable, though diamonds are more expensive, more aggressive, and in my experience, have a longer lifespan. Steel cutters are handy, and are less expensive than most other cutters, and they leave the surface with quite a smooth finish. They don't seem to last as long as the other cutters, however.

Texturing stones generally are available in white, gray, and red, and come in a variety of shapes and sizes. These stones differ in the coarseness of their cuts, white being a fine cut, gray a medium, and red the coarsest. They are quite inexpensive. I suggest buying the barrel or cylinder shape in different diameters and lengths. You can work these stones into customized shapes using a dressing stone.

Assortment of diamond bits: ball (#1), small flame (#2), large flame (#3), bullnose (#4).

Numbers 5–7 in the above photo are texturing stones in various shapes I have made for different purposes. These were all barrel-shaped stones that I customized. The end of #5 is shaped to a ⅛-inch ball to texture smaller feathers and also clean rough areas. Number 6 has been only slightly rounded at its end to remove the sharp corner and is used to texture breast and rump feathers. The flame-shaped tip of #7 is very handy for getting into hard-to-reach areas.

The cutters and stones are mounted in a high-speed rotary grinder that can be held like a pencil and gives you great control and dexterity. A control allows you to adjust the speed from zero to 55,000 rpm. Usually, the faster the rpm, the smoother the cut.

Burrs, cutters, and stones become clogged and dirty with use. Don't throw them away—you can clean them by soaking them in a liquid oven cleaner overnight. Be careful when using the oven cleaner. It is quite corrosive, so use a metal container and wear rubber gloves. After soaking the bits, use a stiff brush and lots of running water to clean off the loosened debris. A rotary steel wire brush is helpful for removing any last little bits that are really stuck. As an alternative to brushing, you can use an ultrasonic cleaner to remove the loose debris after thoroughly rinsing the bits in cold water.

Ultrasonic cleaner.

Safety

All the way through the carving procedure—during the band sawing, roughing out, sanding, texturing, and burning—wood dust and other contaminants will be in the air. Your primary defense is a good dust mask that will filter out the smallest particulates. Check with your supplier to determine which mask is best for your situation. Dust masks may be uncomfortable and cumbersome, but they will help protect you. Another necessary piece of equipment is a dust collector that will remove the dust from your work area on a continual basis.

When using burrs, cutters, and stones, never exceed the manufacturer's rpm rating for the particular bit you're using. If you do, dangerous things can happen. The shaft can bend, causing the burr to spin around like a propeller and possibly hit you or destroy your finished surface, and the cutting head can dislodge from the shaft and become a missile. Always wear safety glasses or goggles when using any power tool.

While burning, never burn any area on which you may have used cyanoacrylate glue, or superglue, as the fumes contain carcinogens, agents known to cause cancer. Fumes are also released during the sealing process, so do this work in a well-ventilated area to prevent inhalation. If you are using an airbrush to paint, you should do this in a well-ventilated area as well.

Roughing Out the Carving

Now begin roughing out the carving with your band saw. Cut out the top view first.

3

Here are the scrap pieces after cutting out the top view.

4

Reattach the scrap pieces from the sides with masking tape, making sure all pieces are aligned correctly.

5

LIST OF CARVING SUPPLIES

Following are the tools and materials I used to carve these birds. Feel free to substitute tools with which you are comfortable. Use what works for you; there are a number of tools that will do the same job.

- Reference material: photos, patterns, mounted birds, study bill
- Safety glasses or goggles
- Dust mask
- Dust collector
- Incandescent light source
- Life-size patterns
- #2 soft lead pencil
- Eraser
- High-speed rotary grinder
- Band saw and drill press
- Folding handsaw
- $1/16$-inch drill bit
- Small and large Forstner bits for hollowing
- Tupelo wood: $10\frac{1}{2}$ x $5\frac{1}{4}$ x 4-inch block
- Measuring tools: dividers, calipers, vernier calipers
- Assortment of burrs, cutters, and stones, including carbide cutter, small flame-shaped cutter, $1/8$-inch ball-shaped stone, rounded-end cutter, small red stone with corner slightly rounded, safe-end diamond cutters, tapered safe-end diamond, large flame-shaped diamond, red texturing stones
- Clear plastic wrap
- Tank for flotation
- Masking tape
- T square
- Woodburning system with burning pens, such as Detail Master pens 10B and 1C
- 80-, 150-, 220-, and 600-grit sandpaper
- Sharp knife
- Water soluble wood filler
- Circle gauge (from office supply store)
- 8mm eyes: hazel for hen, brown medium for drake
- Lacquer-based wood sealer

CARVING

Turn the block 90 degrees, and cut out the side view. Keep the scrap piece from the back (top) of the cutout to use for supporting the roughed-out carving if you need to hollow it later for flotation. Putting it back in place will establish a flat surface to rest on the drill press table.

6

The shadowed areas will be removed to establish the outside dimensions of the head.

7

8

9

10

The folding Dozuki handsaw is used to remove scrap pieces from around the head.

11

CARVING

After the shadowed areas have been removed, draw the side profile on each side of the remaining area, making sure that the two sides line up exactly with each other. Use the center of the eyes as reference points to line up both sides.

12

13

14

15

Carefully use a band saw to remove excess wood to form the top profile of the head and bill. When doing this, use a piece of the scrap wood from the side of the head to hold the head parallel and flat to the saw's table surface. This stabilizes the head to make the cut safer. If you're not comfortable using the band saw for this step, you can use a flexible-shaft grinder with a large, barrel-shaped coarse cutter to remove the excess wood, as in the next step.

16

17

CARVING 9

Remove the shadowed areas to form side profiles of the head and bill, using a flexible-shaft grinder with a large, barrel-shaped coarse cutter. Be sure the sides are parallel with each other and square to the top of the head.

Photos 20 through 25 shows reference lines used during the roughing-out process. The pointers indicate the highest and widest areas on the carving.

Photos 26 through 28 show side, front, and top views of a shadowed area to be removed to lift the wing from the side of the body.

CARVING 11

Photos 29 through 31 show the carving after I removed the wood in the shadowed portions of the previous photos.

The shadowed areas in photos 32 and 33 are to be removed to form the lower surface of the tail and the lower rump.

Photos 34 through 36 show the carving after the wood in the shadowed sections has been removed.

12

CARVING

Arrows in 37 through 40 indicate the areas to be removed to round out the lower half of the body along and under the tail.

CARVING

Photos 41 through 43 show the front, back, and side views where wood has been removed to round out the bottom of the bird.

The shadowed areas in photos 44 through 47 indicate the wood to be removed to form the upper rump and tail area.

41

42

43

44

45

46

14

CARVING

47

In photos 48 through 51 the wood has been removed to form the upper rump and tail area.

48

49

50

51

CARVING 15

Photos 52 through 55 shows both side views, the top view, and the back view, with the shadowed areas to be removed to form the location of the primaries and complete the upper rump. On the back view, the left side is the high primaries, and the right side is the lower set of primaries. Pointers indicate areas where wood will be removed.

52

53

54

55

Pointers in photos 56 through 59 indicate where wood has been removed to form the location for the primaries and the upper rump area.

56

57

16

CARVING

58

59

61

62

Now it's time to work on rounding out the top half of the body. Photos 60–63 shows reference lines, indicated by pointers. Rough out the body from the top to the side and rough out from where the head meets the body to the reference line on the breast. When roughing out the side where the wing is exposed, work from the reference line on the top of the back to the edge of the exposed wing. Also rough out the upper rump area, rounding it out to the upper tail surface.

60

63

CARVING 17

Here you can see where you drilled the reference hole at point A to the depth of point B when transferring the patterns. This point is the convergence of the side pocket, breast, cape, and scapular feathers groups. When roughing out of the top half of the body, use this drilled hole as a reference point. Remove wood down to the bottom of this hole, blending from the highest and widest areas of the side pockets, breast, cape, and scapular feathers to this point.

64

Photos 66–69 shows the upper half of the body that has been roughed out.

65

66

67

68

69

The next step is to outline the major feather groups: side pockets, scapulars, cape, exposed wing, and lower rump. These areas have been shadowed to indicate the wood that will be removed to form these feather groups.

70

71

72

73

74

CARVING 19

When removing the wood to form the major feather groups, make these cuts at 90-degree angles.

75

76

77

78

79

After outlining the major feather groups, round them to the widest or highest area, then sand them smooth to eliminate any tool marks.

80

20　　　　　　　　　　　　　　　　　　　　　　　　　　　　　　　　　　　**CARVING**

CARVING 21

Roughing Out the Head and Bill

The next step is to shape the head and bill, beginning with the top surface of the bill. First draw the side profiles of the bill on the cutout, being sure that they are lined up accurately from side to side. Remove wood down to the top pencil line on each side of the bill, leaving the center high. Then remove wood from the center until this area is flat from side to side. This will give the bill an accurate top profile. Then redraw the center line.

The shadowed areas indicate the wood to be removed to form the lower surface of the bill and the upper surface of the breast.

CARVING THE BILL

❶ Remove wood side to side from centerline down to profile lines of the side of bill.

❷ Then remove center portion, forming a flat surface side to side.

22 CARVING

The wood has been removed to form the lower surface of the bill and the upper surface of the breast.

The shadowed areas in photos 92–96 indicate the wood to be removed to form the rough shape of head.

89

90

91

92

93

94

CARVING

23

Using a large, barrel-shaped coarse cutter, remove the wood at roughly a 90-degree angle from the cheek line up along the side of the crown area, outlining the crown area and the wider cheek area.

After shaping the head, round the crown area over to the cheek line, then round the cheek area over to the widest point on the cheek, indicated with an X on the pattern in the back of this book. Soften the look of the head by rounding it toward the bill and the back of the head.

104

105

106

Sanding

After you've roughed out the cutout, sand the entire bird with 80-grit sandpaper. Keep sanding with finer and finer sandpaper, ending with 600-grit, which leaves a smooth, almost polished surface on which to apply the texture.

Always sand with the direction of the grain, and don't work the surface too much. If the grain becomes raised from the surface, it will show after the bird is painted and is rather unsightly.

Using the sandpaper with just your fingers and hand works well, but sometimes it's better to use a backer. The friction can generate a lot of heat and some discomfort, and a backer can do the work and lets you get into tight corners. You can improvise and use any backer that will take the shape of the surface being sanded. A rubber pad, for example, could be shaped to fit the situation. Wrap the sandpaper around it and sand away.

Setting the Eyes

Establish the center of each eye by taking the distance from the tip of the bill to the center of the eye from the pattern and transferring this to the wooden bird (Note that these photos show the drake).

107

Mark horizontal and vertical lines 90 degrees to one another through the center of the eye, forming a cross. Using a circle gauge, line up using the crossed line through the center of the eye with the correct size circle, and outline the circle with a pencil. Do this on both sides of the head, making sure they are symmetrical.

108

109

Drill holes ¼- to ⅜-inch deep for the eyes in each side of the head, ensuring that they are symmetrical from every angle.

110

111

CARVING 27

Set the 8mm eyes in place, securing them with a water-based wood filler. Use plenty of filler, because it has a tendency to shrink.

112

113

Photos 114 and 115 show the head with the eyes in place.

114

115

This is a tool I developed to adjust the positioning of the eyes by pushing on them as required. No, I don't sell these, but you can easily make your own. Carve a dimple into one end of a piece of scrap wood (I use pine) approximately ¼ inch square and 6 to 8 inches long. This allows it to fit over the eye, letting you apply considerable pressure while you adjust its position.

116

The head is sanded, the eyes are set and the bill is complete. Now apply wood sealer to seal the surface of the bill and harden it slightly to prevent damage. Photos 117–120 show the head at this stage.

117

118

119

120

Flotation and Hollowing the Carving

At this point it's time to float the carving. Begin by marking a pencil line approximately ¾ inch up from the bottom parallel to the circumference of the body. (If you are carving a different duck species, do some research to determine the correct flotation, as some float higher or lower on the water.) Wrap the bird in clear plastic wrap to protect it from moisture, and then place it in water. A transparent tank makes viewing the carving easier while it is floating. Look for the pencil line you just drew. If the carving floats even with this line, no hollowing is required. If it floats too high, you need to add some weight to the bottom of the bird to correct flotation. If it sits too low in the water, you need to hollow the bird.

Hollowing your carving will lessen the internal stress on the wood and help prevent cracking. Any hollowing should be done now to prevent creating any irregularities in the finished surface.

To hollow the bird, first draw an oval on the bottom of the carving approximately ½ inch in from the edges. Then make a pattern from this oval, and use it as a template to cut out a ⅜-inch-thick blank to cover the hole you will make.

121

Take the scrap piece you saved from the back of the bird while band sawing, and attach it to the roughed-out body with masking tape. Using a drill press and Forstner bits, cut out the oval, making your first cuts about ⅜ inch deep to accommodate the previously cut blank.

122

Once the blank fits correctly, draw another oval approximately ¼ inch inside the first one, thus leaving a shoulder to glue the blank to. Remove more wood from within this second oval to make the carving lighter.

123

Refloat your carving at this stage. If it floats correctly, then you can fasten the blank into the bottom of the carving with waterproof glue.

Shaping the Exposed Wing

The next step is to shape the exposed wing. The shadowed areas need to be removed to undercut the wing.

124

125

126

Removing the shadowed areas lifts the wing from the body. Do not make the leading edge of wing too thin; on the real bird, it is quite meaty.

127

128

129

130

CARVING 31

Finishing Your Carving

With the exception of the tail, exposed wing, and primary feathers, I usually start at the back of the bird and work forward, finishing with the head. Do the underlying feathers first. For example, the tertial feathers are underneath the scapulars, so you would do the tertials first. Finish the top surface of the feathers before doing the final undercutting. This gives you a firmer surface to work on and helps prevent the finishing techniques from penetrating through the feathers, causing unsightly mistakes. After the upper surface of the feathers, such as the primaries, is complete, you then do the final thinning by undercutting in this area.

Pencil in the feather groups, then carve them to their finished size and shape, and sand them smooth. When you are carving an exposed wing, look closely at your reference to study the flow of the feathers and how the groups overlap.

The flow of feathers is very important to give your carving a pleasing appearance. To help with this, take the time to draw flow lines before drawing the feathers. Photos 134–139 show the flow of feathers from the head through the body and ending at the tail.

32

CARVING

136

137

138

139

Now spend some time researching the sizes and shapes of the feathers on the species you are carving. Feathers differ among species and even between the hen and drake of the same species. Then draw all the feathers on the surface of the carving, using the flow lines as a guide.

140

141

CARVING 33

142

143

144

145

Begin undercutting in the primary area to finish forming the upper rump area. The primaries are left thick to assist with the finishing on the top surface. They will be thinned after the top surface of the primaries is completed.

146

Here the tertial primary area is ready to finish.

After the tertials and primaries have been carved individually, and the undercutting has been finished under the primaries, sand them to a 600-grit finish. They are now ready for burning.

147

148

149

150

151

152

CARVING 35

Now complete the exposed wing. Because the feathers on the wing tend to have a stiff appearance, outline each one with a clean, crisp edge, using a safe-end diamond and then a burning pen held flat on the surface of the lower feather. Then sand the area smooth to a 600-grit finish. If you don't sand your carving, any unwanted tool marks will be enhanced many times over during the painting process, leaving unsightly areas on your finished bird. After sanding, burn each feather to simulate real feathers.

Here the tertials and primaries are completed.

BURNING

Woodburning pens come with straight or rounded burning edges. The rounded edge is good for hard-to-reach areas, such as under the chin, the back of the neck where it meets the cape, and the smaller breast and rump feathers. The straight edge helps you keep the burn lines parallel and neat and is used on the larger feathers, tertials, scapulars, and side pocket feathers.

Burning pens used to burn in texture on the bird's finished feathers.

Burning can add softness and realism to individual feathers if done with care and understanding. It doesn't really matter how many lines per inch you can burn, though the closer together they are, the better the effect. It's more important to keep burn lines parallel to one another, giving some S-shape to each line. Avoid a "Christmas tree" appearance; don't overlap your burning or burn straight lines projecting from the center of the feather as shown in the figure.

LIKE THIS
Burn lines parallel with each other with subtle S curves.

NOT THIS
Burn lines straight and crossing over. "Christmas tree"

When burning, always keep the tip of the woodburning pen perpendicular to the surface. If you hold the pen at an angle, it has a tendency to slip across the surface, cutting shavings of wood and making a mess.

Keep pen 90° to work surface

To burn individual barbs on the feathers, place the tip of the pen on the surface, and draw the pen back as you lift it off the surface. This will cause the lines to be burned deeper at the start and shallower at the end. When you use this technique, interesting visual patterns will emerge, adding more realism to your feathers.

Lift pen off surface as you draw pen back

As you work on burning your carving, keep the tip of your pen clear of carbon buildup. Wipe it with a piece of cloth, such as denim, which is rough enough to clean the pen but not so abrasive as to cause premature wear on the burning edge.

CARVING

Now complete the upper rump area. The upper tail coverts—the first row of feathers next to the tail feathers—overlap from the outside toward the middle, contrary to what you might think.

Outline the lower rump and flank area feathers, then apply texture with a red stone with the corner slightly rounded. Finish each feather by texturing it with a burning pen.

Outline each feather on the scapular and cape area with a diamond ball cutter. Where small groups of feathers converge, make these cuts deeper than the surrounding feathers to add depth to the finished area. Once the feathers have been outlined, round them off onto the feathers below; then sand them ultrasmooth, leaving no hard edges or tool marks. Next, texture individual feathers with a rounded-end red stone; then burn them to give definition to each.

CARVING 39

The side pocket feathers are carved somewhat deeper than the scapular feathers to make them look softer and fluffier. Follow the same procedures as for the scapular groups.

168

169

170

171

172

Now it's time to work on the breast area. Take note of the pattern and flow of the feathers. First texture feathers individually with a red stone with the corner slightly rounded; then arbitrarily choose small groups of three or four feathers within the breast, and gently run the red stone through these groups, creating a flow through the breast area.

173

174

175

176

Draw flow lines on the head to give a pleasing look to the finished bird. Add texture with a small square-end stone, then burn individual feathers to give them definition.

177

178

CARVING

41

The tail feathers are stiff, so outline them as you did the feathers on the exposed wing, and then burn individual feathers to give them definition.

42 CARVING

Here's how your bird should look after it's been carved and burned. It's now ready for sealing and painting.

CARVING

CARVING

Painting Basics

Once you have completed the carving process, it's time to finish it with sealer, gesso, and paint.

Applying Wood Sealer

Seal the completed bird with two or three applications of a good lacquer-based wood sealer. I use Deft Clear Wood Finish, first filtering off any solids, which would have a tendency to fill up some of the texture I worked so hard to achieve. I also dilute the sealer with lacquer thinners to approximately a fifty-fifty blend. This helps the sealer soak into the wood. I use two or three applications to protect the wood from any moisture. Always apply sealer in a well-ventilated area. Allow it to dry thoroughly before applying the gesso.

Here's the completed and sealed carving.

45

Applying a Gesso Coat

The wood sealer on your carving has a tendency to prevent the acrylic colors from adhering well to the surface. That is the primary reason for the application of a gesso coat. Gesso gives the sealed surface some tooth, providing the paints with something to adhere to. Make two shades of gray by tinting white gesso with burnt umber and ultramarine blue for a dark value and raw sienna for a lighter value. The reason for using gray shades of gesso is that this is a neutral color and is easy to cover with coats of paint. The lighter and darker values represent the lighter and darker areas on the bird. Thin these mixtures with water to the consistency of milk.

The hen and drake are both gessoed with dark and light values.

Using a relatively stiff-bristle brush, apply the light and dark shades of gesso to the appropriate areas of your carving, as shown in the photos. Always brush in the direction of the carved texture. If you don't, you could lose some of the texture you carved by filling it with gesso. Where the dark and light shades meet at the shoulder and on the head, blend them softly together. It is important to always blend the areas where colors meet, even at this stage, to make your finished bird look as soft as possible.

One thin coat of gesso is sufficient. The reason for applying gesso is to help the paint adhere properly. You don't need to use it to make any underlying color, such as burn lines, disappear. One thin coat is enough, even if color is showing through.

Do not use an airbrush to apply gesso. This makes tiny bubbles on the surface, creating unsightly blemishes that are hard to cover with paint.

Allow the gesso coat to dry thoroughly before applying the acrylic colors. If you don't let each coat dry thoroughly as you work, further applications will lift the wet paint off the surface. I do not advise force-drying the gesso coats, as this leaves small imperfections in the finish. Once the gesso is dry, inspect the entire surface for any imperfections, such as hairs or foreign particles. This is the time to do any repairs as required. If you made the head separately from the body, any trouble areas will show clearly after the gesso is dry.

PAINTING BASICS

Brushes

You have an abundance of choices when selecting brushes, but you can create a wonderful finish with the use of just a few. Each brush has a specific use. A ½-inch stiff-bristle brush is used to apply the gesso coat. A #4 hog-bristle fan blender is excellent for blending large areas of color on the surface of your carving. An assortment of soft blending brushes, usually synthetic or camel hair with domed or rounded tops, is always useful. The #6 synthetic rounds are less expensive brushes used to mix paints and apply them to the surface. Use #6 and #12 filberts to edge individual feathers and #2 and #4 round kolinsky sable brushes for fine detail, such as splits and feather edges. Purchase the best-quality kolinsky sable brushes you can. A good-quality kolinsky sable lasts a considerable length of time, as long as it is properly maintained, and it will hold an extremely fine point. A natural material, kolinsky sable has a memory, which springs the brush back to its original shape, forming this fine point. To facilitate fine painted detail, you can form a sharp point or chisel point.

Fan blenders.

Filberts (cats paws).

LIST OF PAINTING SUPPLIES

- Containers for water
- Palette for mixing paints
- Paper towels for cleanup
- Portable hair dryer (optional)
- Cotton balls

Brushes
- #2 and #4 round kolinsky sable
- #6 round synthetic bristle
- #6 filbert, ¼ inch wide
- #10 or #12 filbert, ½ inch wide
- #4 and #6 hog-bristle fan blenders
- Set of soft, fluffy blending brushes
- Airbrush and templates (optional)

Paints and Finishes
- White gesso
- Gloss medium
- Burnt umber
- Raw umber
- Ultramarine blue
- Carbon black
- Raw sienna
- Burnt sienna
- Warm white
- Nimbus gray
- Cadmium yellow medium
- Phthalo blue
- Phthalo green
- Payne's gray
- Yellow oxide
- Gold oxide
- Smoked pearl
- Brilliant green
- Yellow green interference

Quality kolinsky sable rounds.

PAINTING BASICS

You can form different points on a kolinsky sable to facilitate finely painted detail: Figure A shows a sharp point; Figure B is a chisel point.

Rotate

Draw back, forming a sharp point

Draw back and flatten, forming a chisel point.

A

B

Side

Front

Good-quality kolinsky sable brushes are handmade. The bristles are hand rolled and naturally form a fine point. Synthetic brushes are machine made and mechanically shaped to a point. Usually the synthetic hairs are trimmed to shape, and being synthetic fibers, they tend not to have a memory, causing a bent tip to form permanently, rendering the brush unusable for fine work. Synthetic brushes also have a tendency to splay open and lose their shape. So be sure to purchase natural kolinsky sable, not synthetic, for your fine detail work.

Maintenance of your brushes will make them last longer and perform better. First, thoroughly clean each brush with warm water and mild hand soap, working the bristles until no more color comes out, and then rinse thoroughly. Next, massage a conditioner for brushes into the bristles to give them renewed life, and rinse again thoroughly with warm water. The last step is to dip the bristles into a sizing, which reshapes the brush and dries it to its original form, ready to use next time. You don't rinse off the sizing, which is made to dry on your brush to hold the pointed shape and help your brushes last longer.

A kolinsky sable brush holds an extremely sharp point because of memory. A synthetic bristle brush forms "bent tip syndrome" because of lack of memory, which makes it very hard to aim and paint a fine line.

PAINTING BASICS

Mixing Colors

When mixing colors, it's important to know what pigments are in each of the tube colors you're mixing, or you may not end up with the color you want. Most tube colors are made up of different pigments. For instance, warm white is a mixture of two pigments: titanium white (PW 6) and yellow oxide (PY 42). If you were trying to achieve a light blue color and added warm white to ultramarine blue, the resulting lighter blue would have a greenish hue to it because of the yellow oxide in the warm white. A better choice would be titanium white, which would give a true light blue color. All manufacturers of top-quality paints list pigment colors contained on the tube of paint or a separate technical sheet.

Mix your colors on a palette. I prefer to use disposable palettes, which require less cleanup than a wood or plastic palette.

Blending Colors with Brushes

To achieve softness, you need to blend the colors on your carving. You can use blending brushes or an airbrush. For the projects shown in this book, I used an airbrush for reasons of time, but all the blending could have been accomplished with brushes using the following simple techniques.

First, use water and flow medium to mix puddles of each paint color to the consistency of cream. When you mix your paint on the palette and lift the mixing brush from the puddle of paint, the paint should form a round bump on the surface that immediately flows down flat into the puddle. If the rounded bump doesn't form, the paint is too thin. If the bump remains after you remove your brush, your paint mix is too thick. If you are mixing larger quantities of paint to store for future use, use flow medium without water. This will help to prevent bacteria from growing in your stored paints. Plastic film canisters make excellent storage containers.

Apply the colors to be blended so that they touch. If you leave a dry area between colors, blending is difficult. When the colors touch on the surface, they should start to bleed, but not run together. This bleed will start the blend. If the blended area is drying too quickly, use a mist of water to dampen the surface slightly. If you have to apply more color to an area because it has become too dark or light, do it while the paint is still wet, and reblend it.

For smaller areas, use a round-end soft blending brush. Draw it back and forth across the color blending zone to achieve the blend you are looking for. Do not blend these areas too much or the colors will become muddy. For soft blends in large areas or groups of feathers, use a fan blender. After applying the paints, first work the fan blender back and forth across the color blending zone to accelerate the blend; then draw it along the

ROUND END BLENDING BRUSH

length of the blending zone, eliminating any brush marks until the desired blend is complete.

Blending brushes should be dry to achieve a soft blend; wet brushes have a tendency to lift or pull the paint from the surface. When you are in the final stages of blending, allow your blending brush to just caress the wet paint as if you don't want the brush to touch the surface of the wood.

Airbrushing

Airbrushing allows you to blend colors more quickly, and the visual effects it adds can be quite dramatic, but be careful not to overdo it. Too much airbrushing will give your carving an out-of-focus, fuzzy appearance. Airbrushed color also has a tendency to be very opaque, so be careful if you want translucence in certain areas.

I use a Paasche AB dual-action turbine airbrush with an external paint cup. The operation of this airbrush is quite simple: you depress the finger button and pull back so that air flows through the unit, causing the turbine to spin, which in turn oscillates the slide that holds the very fine needle, making the needle slide back and forth and pass in front of an air jet. A portion of the needle slides through the front end of the external paint cup, picking up color and passing it in the direct path of the air jet, which atomizes the paint and sprays it onto the surface to be colored. It's as simple as that. Follow the manufacturer's setup procedures for adjustments.

Here are some points to keep in mind when using an airbrush on your carvings: run your brush at approximately 25 to 30 psi. Always make sure the needle is sharp and not bent at the tip. Have enough tension on the needle bearing to allow the needle to run smoothly, with no wobble. Adjust the needle so that it runs through the center of the air jet. And, most important, be sure to keep the airbrush clean. As you can see, most of the focus is on the needle. Pay particular attention to it. Keep it tuned, and you will have many enjoyable hours painting. Don't be intimidated; give airbrushing a try.

Tertial feathers, tail feathers, quills

Smaller, more pointed feathers

Primary feathers

Scapular feathers, side pocket feathers

Tertial feathers, tail feathers

Margins of feathers, bases of feathers, others (use your imagination)

Use templates to outline feather edges and prevent overspray. Making your own templates is easy enough. Find a stiff piece of thin cardboard or plastic that will keep a crisp, clean edge when cut, and cut out templates as required. You really don't need a template for every shape you intend to spray. I have a variety of shapes and sizes but use about half a dozen of them most often.

Other Painting Techniques

When painting your carving, another technique you will use is drybrushing. First load your brush with paint, then dry it on a paper towel, leaving very little paint on the brush. Hold the brush at a very oblique angle to the work surface and draw it gently across the surface, just caressing it, leaving behind small amounts of paint. You may have to repeat this process a number of times to achieve the desired effect.

Other times you may need to use a wash to adjust the look of the colors on your carving. A wash is applied over another coat of paint.

Paints and Mediums

For painting my carvings, I use acrylics exclusively. Acrylic paints are a mixture of binders, pigments, and fillers. The acrylic liquid is the binder, which makes the paint adhere to the surface, holds the pigment together, and becomes hard and durable when dry. The pigments are the color portion of the paint. Fillers, which are other materials added to the paint to give it various qualities, have a tendency to make the paint dull. When choosing paints, try to find ones with as little filler as possible. Fillers and binders cause the colors to darken as the paints dry, making it somewhat difficult to mix the desired colors on your palette. With experience, however, the process of mixing becomes easier and less of a mystery. As a rule of thumb, always mix acrylic paints lighter than you require, because they will dry darker on the finished surface.

Paints also come in warm and cool colors. In general, warm colors are those on the red to yellow side of the spectrum, and cool colors are those on the blue to green side. As a rule of thumb, I generally use warm colors for highlighted or raised areas and cool colors for the shadowed or hollowed (low) areas. This imparts a softer, deeper look to the painting.

Value or hue refers the dark or light appearance of a given color. For example, you can darken cadmium yellow with yellow oxide or lighten it with titanium white, ending up with the same color with a darker or lighter value or hue. Intensity or chroma refers to how dark or light one color is compared with another. The overall warm or cool effect is also important to your finished carving. For example, the overall appearance of a red-breasted merganser hen is a warm gray, whereas that of a common merganser hen is a cool gray. Paints also can be broken down further into the earth tones: burnt umber, raw umber, burnt sienna, and raw sienna.

Paint deposited on one side only

Brush at oblique angle

Textured surface cross-section

DRYBRUSHING

An important consideration when choosing paints is whether they are transparent or opaque. Transparent paint allows light to pass through it, revealing some of the color underneath. With opaque paint, light can penetrate just a short distance into the layer of paint, reflecting only the color applied. Think about what effects you want to achieve on your carving.

Paints are also rated for lightfastness by the American Society of Testing and Materials (ASTM), and this rating represents their permanence and colorfastness. Whenever possible, select paints with a lightfast rating of ASTM 1 (excellent). Artist-quality paints are rated as either ASTM 1 or 2. Paints with a rating of ASTM 3 or 4 are not colorfast or permanent and have a tendency to fade quickly, usually within two to three years. You want your carvings to last for generations to come.

The number of colors available is countless, but different manufacturers may use different names for the same color. For example, one manufacturer lists phthalocyanine green as monestial green, another as phthalo green, and another windsor green. There may be other names for it as well, but all are phthalocyanine green. Be careful or you might double up on some of your colors without realizing it. Your supplier should provide this information for you.

You can add matte or gloss mediums to your paint color mix to adjust the shine—matte to give the paint a flatter finish or gloss to make it shinier. Use sparingly; a little goes a long way. Another additive is flow medium, used to make the paint flow from your brush easier.

The paints that I prefer are the Chromacolour Artist Colours, available from Chromacolour International, 1410 28th St. NE, Calgary, Alberta, Canada T2A 7W6, (800)665-5829, www.chromacolour.com. The company also has a fine line of inexpensive, high-quality paintbrushes. I have been using these products for a number of years and have been thoroughly satisfied.

Basic Steps for Painting Your Carving

1. Mix your paints to the correct consistency and colors.
2. Base-coat areas to represent the final colors as required. Blend wherever two colors meet to create softness.
3. Let the paint dry thoroughly. Acrylic paints can be force-dried with a hair dryer if needed.
4. Apply the final colors to each area, and blend on individual feathers to eliminate any hard lines. Do not blend too much, or the colors become muddy.
5. Finish individual feathers with detailed painting. Paint colors on margins, and add paint splits and quills as desired.

The basic steps above are repeated time and again during the painting process to complete the carving. What changes is the mixed colors of paint required.

For both the hen and the drake demonstrations, I applied the base of color with an airbrush to facilitate blending, but you can achieve the same results using blending brushes. Whichever you use for your base coats, complete the detail work on individual feathers with top-quality kolinsky sable brushes.

As you advance through the section on painting your hen or drake, the techniques employed will build on one another so that what you learn on the tail is reinforced through each succeeding step of the painting procedure. Where possible, before (gesso coats and base coats) and after (finished) photos are given for comparison.

Painting the Green-Winged Teal Hen

Following are the painting schedules and pictorial guides used to paint both the hen and drake green-winged teal. Where colors are listed as a mixture, the first color is the main one and subsequent colors are added in lesser amounts until the desired color is achieved. Paint color swatches are also provided, each listing the areas, individual feathers, and uses for that particular color.

After the gesso coat is completely dry, it's time to apply the acrylic colors. Start at the tail end of the bird and progress forward, painting the underlying feathers first. For example, the tail feathers lie under the tail coverts, which are under the rump feathers, and so on. Doing this gives you more control and less cleanup.

Begin by painting the upper surface of the tail. Basecoat the entire surface, using a dark value made from burnt umber mixed with ultramarine blue for the central portion, and a lighter value made from warm white tinted with the dark value for the outside area.

Once you've applied them to the appropriate areas, blend the edges where the colors meet. Finish the individual feathers using the same dark value, but this time a mix of warm white, raw umber, and raw sienna for the light value. Starting at the outside feathers, work forward to the center of the tail. Apply the dark value to the center of each feather and the light value to the outside edges, and blend them softly.

After the surface is dry, use the dry-brush technique to randomly apply a mixture of burnt umber and raw sienna as an intermediate color between the dark centers and light margins. Mix warm white and raw umber, and paint a very fine line around the margin of each feather. Then paint quills with burnt umber mixed with gloss medium.

Base-coat the entire lower tail feather area with a darker medium gray value made from burnt umber, ultramarine blue, and warm white.

4

Once dry, apply this same gray to the center of each feather and lighter value made from a mix of warm white, raw sienna, and raw umber along the edges. Blend where the two values meet.

5

Then lighten the lighter value with more warm white, and use this to paint a margin on each feather. Use the darker medium gray color for the splits. Paint the quills with warm white and raw sienna mixed with gloss medium.

6

Next, base-coat the upper tail coverts and upper rump with a dark value of burnt umber and ultramarine blue and a light value of warm white mixed with raw sienna and raw umber.

7

Finish the central area on the individual feathers. Each feather has a dark band of burnt umber mixed with ultramarine blue on each side of the quill, and on top of that dark band is a light band of warm white mixed with raw sienna and burnt sienna.

8

Use the same dark value for the splits, and paint the quills with burnt umber mixed with gloss medium.

9

PAINTING THE GREEN-WINGED TEAL HEN

53

HEN PAINT SWATCHES

1. Gesso dark value: white gesso, burnt umber, and ultramarine blue.

2. Gesso light value: white gesso and raw sienna.

3. Upper tail and primary feathers dark value: burnt umber and ultramarine blue.

4. Upper tail light value: warm white, raw umber, and raw sienna.

5. Upper tail medium value, lower tail coverts dark value, and markings on head: burnt umber and raw sienna.

6. Upper tail and scapular margin color: warm white and raw umber.

7. Lower tail dark value and primaries and tertials light value: burnt umber, ultramarine blue, and warm white.

8. Lower tail light value and primaries margin color: warm white, raw umber, and raw sienna.

9. Lower tail quill color, lower rump light base color, and lower tail coverts margin color: warm white and raw sienna plus gloss medium when painting quills.

10. Upper rump, upper tail coverts, lower rump, tertials, scapulars, cape, side pockets, and breast and head dark value: burnt umber and ultramarine blue.

11. Upper rump, upper tail coverts, side pockets, and breast light value; head medium value; lower rump individual feather margin color; and lower rump and flank base coat: warm white, raw sienna, and raw umber.

12. Tertial margin color, upper rump, upper tail coverts, scapular and side pocket interior V markings: warm white, raw sienna, and burnt sienna.

13. Lowest tertial and scapulars light value, and greater wing coverts gray value: burnt umber, ultramarine blue, and warm white.

14. Lowest tertial dark value: burnt umber and carbon black.

15. Lesser wing coverts dark value: burnt umber, ultramarine blue, and warm white.

16. Lesser wing coverts and cape light value: burnt umber, ultramarine blue, and warm white.

17. Green secondaries: phthalo blue, cadmium yellow medium, and yellow green interference.

18. Dark secondaries: phthalo blue and carbon black.

19. Rust color on greater wing coverts: yellow oxide and warm white.

20. Bill fleshy color: warm white, raw umber, raw sienna, and burnt sienna.

21. Bill medium value: Payne's gray, raw umber, and warm white.

22. Bill dark value: Payne's gray, burnt umber, and warm white.

PAINTING THE GREEN-WINGED TEAL HEN

Now base-coat the entire lower rump and flank area, with the exception of the lower tail coverts (the first row of feathers next to the undersurface of the lower tail feathers), with warm white mixed with raw sienna and raw umber. The undertail coverts are a mix of warm white and raw sienna.

10

11

To finish individual feathers other than the tail coverts, paint the centers with a dark value made from burnt umber and raw sienna and a light value of warm white mixed with raw sienna and raw umber. The dark center of the undertail coverts is a mix of raw sienna and burnt umber, and the light edges are warm white mixed with raw sienna.

12

Use the same dark value for the splits and the light value to extend the tips of the feathers out onto the dark area of the feather below. To add more depth and softness where the lighter edges of the feathers overlap, lighten the light value with additional warm white, and highlight these areas.

13

Use warm white to extend the margins of the undertail coverts to give more of a feathery look.

14

Base-coat the primaries with raw umber.

15

PAINTING THE GREEN-WINGED TEAL HEN

Paint individual feathers with a dark value of burnt umber mixed with ultramarine blue and a light value of warm white tinted with the dark value.

To finish, use warm white mixed with raw sienna and raw umber to paint a fine line along the margin of each feather. The quills are burnt umber mixed with gloss medium.

Now base-coat the tertials. The lowest tertial on each side has three values. The light value is warm white mixed with burnt umber and ultramarine blue mixed to a very light warm gray. The medium value is burnt umber with ultramarine blue and warm white. The darkest value is burnt umber with carbon black.

PAINTING THE GREEN-WINGED TEAL HEN

Base-coat the remaining tertials with a dark value of burnt umber and ultramarine blue and a lighter value of warm white mixed with burnt umber and ultramarine blue.

20

21

To finish the margins, use warm white mixed with raw sienna and burnt sienna. The quills are burnt umber mixed with gloss medium.

22

23

The next step is to paint the exposed wing. Start with the lesser and medial wing coverts and alula. Base-coat these with a dark value of burnt umber mixed with ultramarine blue and warm white to a medium warm gray and a light value warm white tinted with the dark value.

24

PAINTING THE GREEN-WINGED TEAL HEN

To finish, lighten the light value with additional warm white and use this to outline the margins. Paint the splits with the dark value.

25

Now base-coat the secondaries, or speculum.

26

The lower three secondaries are dark with no apparent green highlights showing. Here use a mix of phthalo blue and carbon black. For the remainder of the secondaries, the dark value is carbon black, used for the shadowed areas, and the light value is nimbus gray, used for the highlighted areas.

27

Finish by painting splits through the shadowed areas on the soon-to-be-green feathers with nimbus gray. To add some life, apply a wash coat of cadmium yellow medium to the highlighted areas on these feathers, using only enough to give these feathers a yellow appearance. After this is dry, use a mix of phthalo green, cadmium yellow medium, and yellow green interference. Thin to a wash consistency, and apply to the green feathers only. It may require several applications to achieve the desired look. Then finish each feather tip with warm white.

28

Base-coat the greater wing coverts with light warm gray made from warm white mixed with burnt umber and ultramarine blue and a rust color made from yellow oxide mixed with burnt sienna and warm white.

29

To finish, lighten the rust color with more warm white, and paint the margins.

30

31

Base-coat the scapulars with a dark value made from burnt umber mixed with ultramarine blue and a light value made from the dark value lightened with warm white.

32

33

PAINTING THE GREEN-WINGED TEAL HEN

To finish, paint the margins with a mix of warm white, raw sienna, and burnt sienna. The central area on each side of the quill has a dark band of burnt umber mixed with ultramarine blue. On top of this dark band is a narrower light band of burnt sienna mixed with raw sienna and warm white. Paint the splits with a mix of burnt umber and carbon black and mix the quills with burnt umber and ultramarine blue mixed with gloss medium. The cape feathers use the same colors but do not have the central lighter markings that the scapulars have.

34

Base-coat the side pockets with a dark value made from burnt umber mixed with ultramarine blue and a light value of warm white tinted with the dark value.

35

To finish, paint the margins with a mix of warm white, raw sienna, and raw umber. The central area on each side of the quill has a dark band of burnt umber mixed with ultramarine blue. On top of this dark band is a narrower light band of warm white mixed with raw sienna and burnt sienna.

36

Use the same dark value to paint splits and the dark value mixed with gloss medium to paint the quills. To make the lower belly feathers look lighter, use the margin color lightened with warm white, and extend the tips of these feathers onto the underlying feathers.

37

38

60 PAINTING THE GREEN-WINGED TEAL HEN

Base-coat the breast with a dark value of burnt umber mixed with ultramarine blue and warm white and a lighter value of warm white mixed with raw sienna and raw umber.

39

To finish, randomly paint lighter feather edges, especially where small groups of feathers converge, using the light value lightened with more warm white.

40

Then paint the splits with the dark value.

41

Base-coat the head with a dark value of burnt umber mixed with ultramarine blue and warm white, a medium value of warm white mixed with raw umber and raw sienna, and a light value of warm white tinted with the medium value. To finish, paint the markings on the face with a mix of burnt umber and raw sienna.

42

43

PAINTING THE GREEN-WINGED TEAL HEN

These views show the finished head. Good reference material is essential here, because people tend to focus on the face and head when they look at the finished bird.

PAINTING THE GREEN-WINGED TEAL HEN

Base-coat the bill with a dark value of Payne's gray mixed with burnt umber and warm white, a medium value of Payne's gray mixed with raw umber and warm white, and a fleshy value made from warm white, raw umber, raw sienna, and burnt sienna.

50

To finish, paint the small spots on the bill using the dark value. I prefer to paint the bill with an airbrush, as it avoids any brush strokes on the surface and makes the painting so much simpler. Once the paint is thoroughly dry (I usually wait overnight), it's time to give the bill its sheen. Buff the surface of the bill with a clean cotton ball until you achieve the luster that you are looking for. Finally, clean any paint from the surface of the eyes.

51

52

PAINTING THE GREEN-WINGED TEAL HEN

63

Here's the completed green-winged teal hen.

PAINTING THE GREEN-WINGED TEAL HEN

PAINTING THE GREEN-WINGED TEAL HEN 65

Don't forget to sign and date your carving.

66

PAINTING THE GREEN-WINGED TEAL HEN

Painting the Green-Winged Teal Drake

After the gesso coat is completely dry, follow the same painting sequence as for the hen, starting to apply the acrylic colors at the tail end and working forward, painting the underlying feathers first.

Begin by painting the upper tail surface with a base coat of burnt umber and ultramarine blue mixed with warm white.

1

Once this is dry, paint individual feathers with the same mix as the base color, applying the dark value to the central portion of the feather and a lighter value made by adding more warm white to the darker value to the edge of each feather. Blend the edges where the two values meet.

2

Finish the individual feathers using warm white mixed with raw sienna and raw umber for the margins. Paint splits with the dark value.

3

Then paint the quills with burnt umber mixed with gloss medium.

4

67

DRAKE PAINT SWATCHES

1. Gesso dark value: white gesso, burnt umber, and ultramarine blue.

2. Gesso light value: white gesso tinted with dark value above.

3. Upper tail base coat, upper tail feathers, primaries, scapulars, and tertial feather base coat and dark value: burnt umber, ultramarine blue, and warm white.

4. Upper tail, center of upper back, primaries, light value scapulars, and tertial base coat and light value: warm white tinted with dark value just above.

5. Upper tail and primaries light margin color: warm white, raw sienna, and raw umber.

6. Lower tail and lesser wing coverts dark value: burnt umber, ultramarine blue, and warm white.

7. Lower tail light value and lower tail quills: warm white, raw sienna, and a touch of the dark value just above.

8. Upper rump, dark patch lower rump base coats, and dark colored spots on breast: burnt umber and ultramarine blue.

9. Upper tail coverts, dark patch lower rump, lower edge of scapulars, lower secondary group, and "ponytail" on head: phthalo green and carbon black.

10. Upper tail coverts light value: warm white, yellow oxide, and raw sienna.

11. Vermiculation on entire bird, secondary shadowed area, and bill: burnt umber and carbon black.

12. Lower rump and breast dark value: warm white, yellow oxide, and gold oxide.

13. Lower rump and flank (ball area) light value: warm white added to the dark value just above.

14. Green patch on secondaries: brilliant green and yellow green interference.

15. Rust color on greater secondary coverts: gold oxide and burnt umber.

16. Green patch on head: phthalo green, cadmium yellow medium, and yellow green interference.

17. Highlights on head: burnt sienna and cadmium yellow medium.

18. Shadowed areas on head: burnt sienna and burnt umber.

Base-coat the lower tail surface with a darker value made from burnt umber, ultramarine blue, and warm white and a lighter value of warm white and raw sienna darkened slightly with the dark value. Apply the same light value to the margins and the dark value to the splits. Paint the quills with warm white and raw sienna mixed with gloss medium.

Paint the primary feathers with the same colors used for the upper tail surface.

Base-coat the upper rump and center of back with a dark value of burnt umber and ultramarine blue mixed to a very dark gray, almost black, and a light value of burnt umber, ultramarine blue, and warm white mixed to a medium warm gray.

After applying these values, blend with a fan blender through the midpoint on the back.

PAINTING THE GREEN-WINGED TEAL DRAKE

Now paint the individual feathers. The upper tail coverts each have a dark center of phthalo green and carbon black and a light edge of warm white mixed with yellow oxide and raw sienna. Apply these colors and blend with a soft, fluffy brush. Do not blend this area too much, or it will become muddy. If you paint these feathers a second time, this will give the blend a softer look. Be sure each coat of paint is dry before applying the next.

Working forward, use the base-coat light value for the lighter edges of these feathers and the dark value for the centers. Gradually apply smaller and smaller areas of these two colors to create smaller feathers, making a soft, gradual transition from the darker tail covert area to the lighter areas on the back. To finish individual feathers, use the dark value to paint splits.

The lighter-colored area is vermiculated. Be sure you have good reference material on hand for the species you're painting, as each has different patterns, sizes, shapes, and colors of vermiculation. For the green-winged teal drake, use a mix of burnt umber and carbon black. A larger #3 or #4 kolinsky sable brush is handy for vermiculation, because it holds a good amount of paint and you can do a larger area before refilling your brush.

Base-coat the lower rump and flank with a dark value made from burnt umber and ultramarine blue and a yellow value made from warm white mixed with yellow oxide and gold oxide.

To finish the yellow area, make a lighter value of the yellow color by adding more warm white and a darker value by adding some raw sienna. To finish individual feathers in the yellow area, tip the feathers with the light yellow value with even more warm white added, using a #10 or #12 filbert brush. Then darken the darker yellow value with a touch of gold oxide and paint some splits. To finish individual feathers in the dark area, mix phthalo green and carbon black, and tip each feather with a filbert brush. Use this procedure two, three, maybe four times on each feather, making each stroke slightly longer than the last. Lift your brush from the surface, applying less pressure, as you draw the brush back. This will darken the ends of the feathers and create a lighter value at the bases, which will establish a soft blend on each feather.

13

To finish the rump area, feather the light color into the dark and the dark color into the light, creating a softer, feathery appearance. The vermiculation is a mixture of burnt umber and carbon black.

14

Base-coat the scapular and tertial feathers with a dark value of burnt umber mixed with ultramarine blue and warm white, and a light value of warm white tinted with the dark value. Apply the light value to the cape and the outside area of the scapulars along the upper edge of the side pocket. Apply the dark value to the remaining area of the scapulars and tertials, and use a fan blender to blend. The lighter value is needed along the bottom edge of the scapulars and on the cape because this area will be vermiculated later. Paint individual tertial and scapular feathers with the base-coat dark and light values. To finish, use the light value to paint the margins. The quills are burnt umber and carbon black mixed with gloss medium.

15

PAINTING THE GREEN-WINGED TEAL DRAKE

The next step is to paint the exposed wing. The bottom tertial feather has three colors. The light value is smoked pearl blended with a warm gray made from burnt umber mixed with ultramarine blue and warm white.

16

The darkest value is carbon black and phthalo green. No blending is required where the dark and light values meet.

17

The first five secondaries are green. Base-coat each feather to create shadows and highlights, using a mix of burnt umber and carbon black for the shadow color and nimbus gray for the highlight color. Also use nimbus gray to paint splits through the shadowed areas.

18

Apply a wash of cadmium yellow light over these green feathers; this will help punch up the brilliance of the finished green color. Then apply a wash of brilliant green and yellow green interference over this area. Let dry, and if required, apply a second coat of the wash to make these feathers brilliant and sparkly.

19

The bottom five secondaries are dark in color. For the bottom three, the dark color is phthalo green and carbon black, with margins of warm white. For the greater secondary coverts, use a rust color made from gold oxide mixed with burnt umber and a light value of warm white. For the lesser and medial wing coverts, use a dark value of burnt umber mixed with ultramarine blue and warm white, with warm white for the edges. The margins are defined using warm white.

20

Finally, base-coat the side pockets with nimbus gray.

21

Take your time on the breast area to make it right. Do not make the yellow area too wide; consult your reference. The base coat is a yellow color that is very similar to that color on the lower rump, made from warm white mixed with yellow oxide and gold oxide. The color along the side is nimbus gray.

22

After the base coat is dry, paint the spots on the breast with a mix of burnt umber and ultramarine blue. Using a airbrush here simplifies application and allows you to make the spots different values of color from dark to light, and also different sizes and shapes. To finish, add more warm white to the light value to paint the edges of individual feathers.

23

The bottom edge of the scapular feathers have a dark edge of phthalo green and carbon black.

24

PAINTING THE GREEN-WINGED TEAL DRAKE

The vermiculation color is burnt umber mixed with carbon black. Vermiculation will make or break the final look of your bird. Study closely the reference material available to you and follow what you see.

Next, base-coat the head. The reddish area around the green patch is burnt sienna. For the green patch, use carbon black for the shadowed areas and nimbus gray for the highlighted areas. Once dry, apply a wash of phthalo green mixed with cadmium yellow medium and yellow green interference. You may have to apply two or more washes to achieve the color you're looking for. On the reddish area of the head, the highlights are burnt sienna mixed with cadmium yellow medium, and the shadowed and darker areas are burnt sienna mixed with burnt umber. To finish the "ponytail," use a mix of phthalo green and carbon black. The light markings around the green are smoked pearl.

Paint the bill with a mix of burnt umber and carbon black. After the bill is thoroughly dry, use a clean cotton ball to buff up the sheen on the bill to the desired luster. Finally, clean any paint from the surface of the eyes.

PAINTING THE GREEN-WINGED TEAL DRAKE

75

Here's the completed green-winged teal drake. Don't forget to sign and date your carving.

PAINTING THE GREEN-WINGED TEAL DRAKE

Taxidermy Photos

This series of photos is of a green-winged teal drake taxidermy mount; use for reference only.

Side of breast and shoulder area.

Upper rump and tail.

Tertial area.

Head and neck.

Breast.

Lower rump and tail.

Back and scapular area.

78 TAXIDERMY PHOTOS

Patterns

GREEN-WINGED TEAL DRAKE

HEAD—SIDE VIEW

HEAD—TOP VIEW

HEAD—FRONT VIEW

BILL

TOP VIEW

80 DRAKE PATTERNS

SIDE VIEW

LOWER RUMP

DRAKE PATTERNS

81

GREEN-WINGED TEAL HEN

SIDE VIEW

HEAD—FRONT VIEW

HEAD—SIDE VIEW

82

HEN PATTERNS

LOWER RUMP

HEAD—TOP VIEW

SIDE VIEW

HEN PATTERNS

83

TOP VIEW

HEN PATTERNS

ABOUT THE AUTHOR

Glenn McMurdo's interest in decoy carving began in the fall of 1985. An avid duck hunter, Glenn elected to make his own working decoys instead of using plastic store-bought blocks. He took a decoy-carving course offered at a nearby high school, which seeded his desire and passion for the craft. Decorative carving was a natural progression, and many awards and rewards followed.

Glenn has written numerous how-to articles, teaches woodcarving and painting, and has judged numerous carving competitions from coast to coast across Canada and the United States. Glenn and his wife, Katharine, reside in Cobourg, Ontario, Canada. Their two children and five grandchildren all live nearby.